Publisher, Editor-in-Cheif, Director of Photography, Director of Operations, and Layout Designer:

Donald C. Evans, Jr.

Special Thanks to the following people and companies:

ModelMayhem.com, Avery Chevious, John Bunch, OMG Magazine, Ralph, Nureign, Michael White, Sirius, John Harmon, Andre Mancel (RIP), Leonard Gartrell, Phillip Stewart, ShooterFotoMagazine, Edward James, Reynold Brockett, Smitty-Bernard Brown, Metta 4, C-Man, and Don Diego.

Advertising information:
Donald C. Evans, Jr. email: donaldeonline@gmail.com
to request an online media kit.

The magazine is distributed to the reader with the understanding that the information and images represented are from various sources from which there can be no warranty or responsiblity by ChocolateBottoms.com Entertainment Cartel or the publisher as to legality, completeness, and accuracy of such material. Editorial contributions are welcomed, inquiries are recommended first. ChocolateBottoms.com Entertainment Cartel assumes no responsiblity for loss or damage to any and all material. Manuscripts must be typewritten and submitted in a word document format. All photographs must be accompanied by captions. Photo model releases are required on all persons in photos. ChocolateBottoms.com Entertainment Cartel reserves the right to use material at its discretion, and we reserved the right to edit material to meet our requirements. Upon publication, payment will be made at the agreed upon rate, and that said rate will cover the autohrs/contributors rights of the contribution.

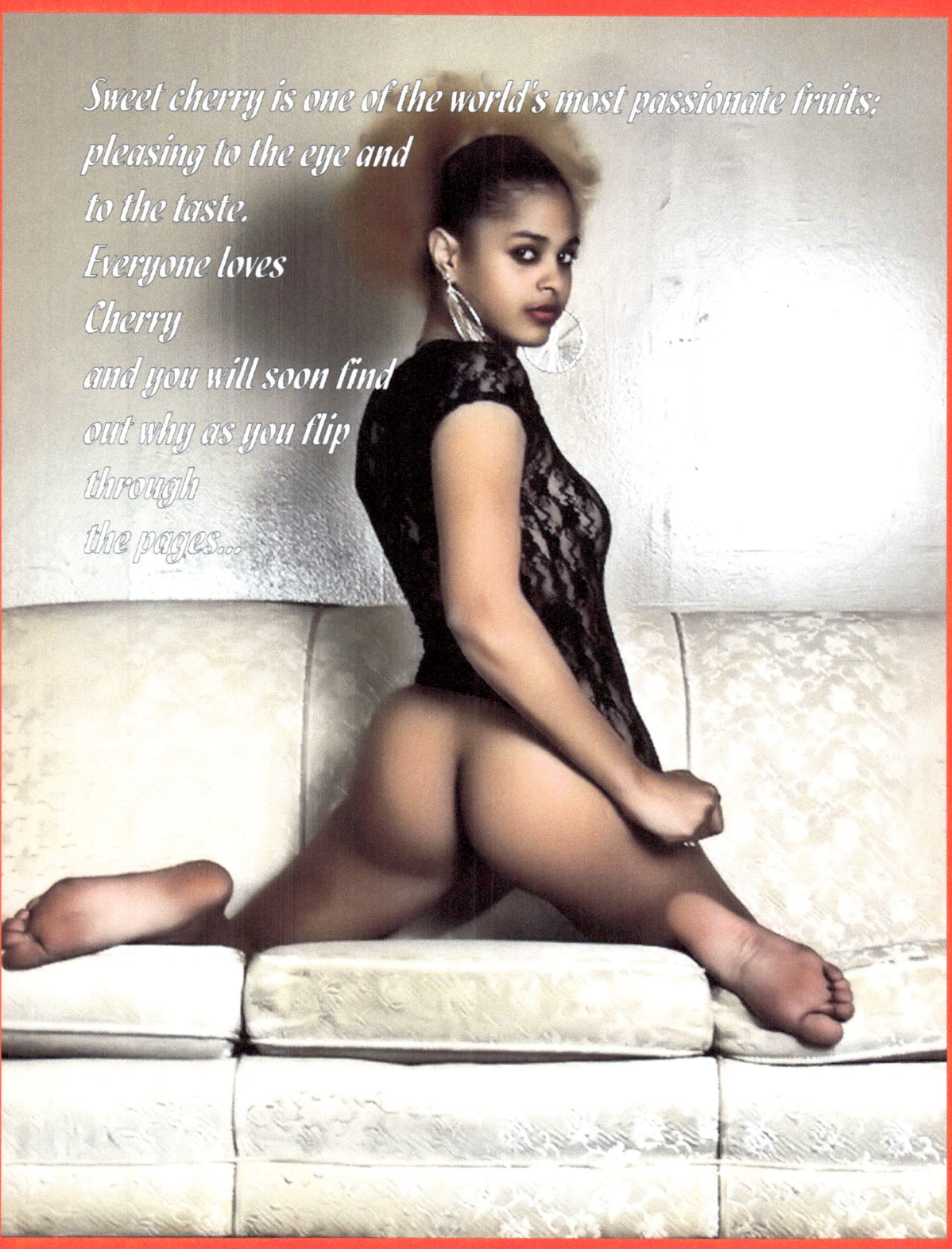

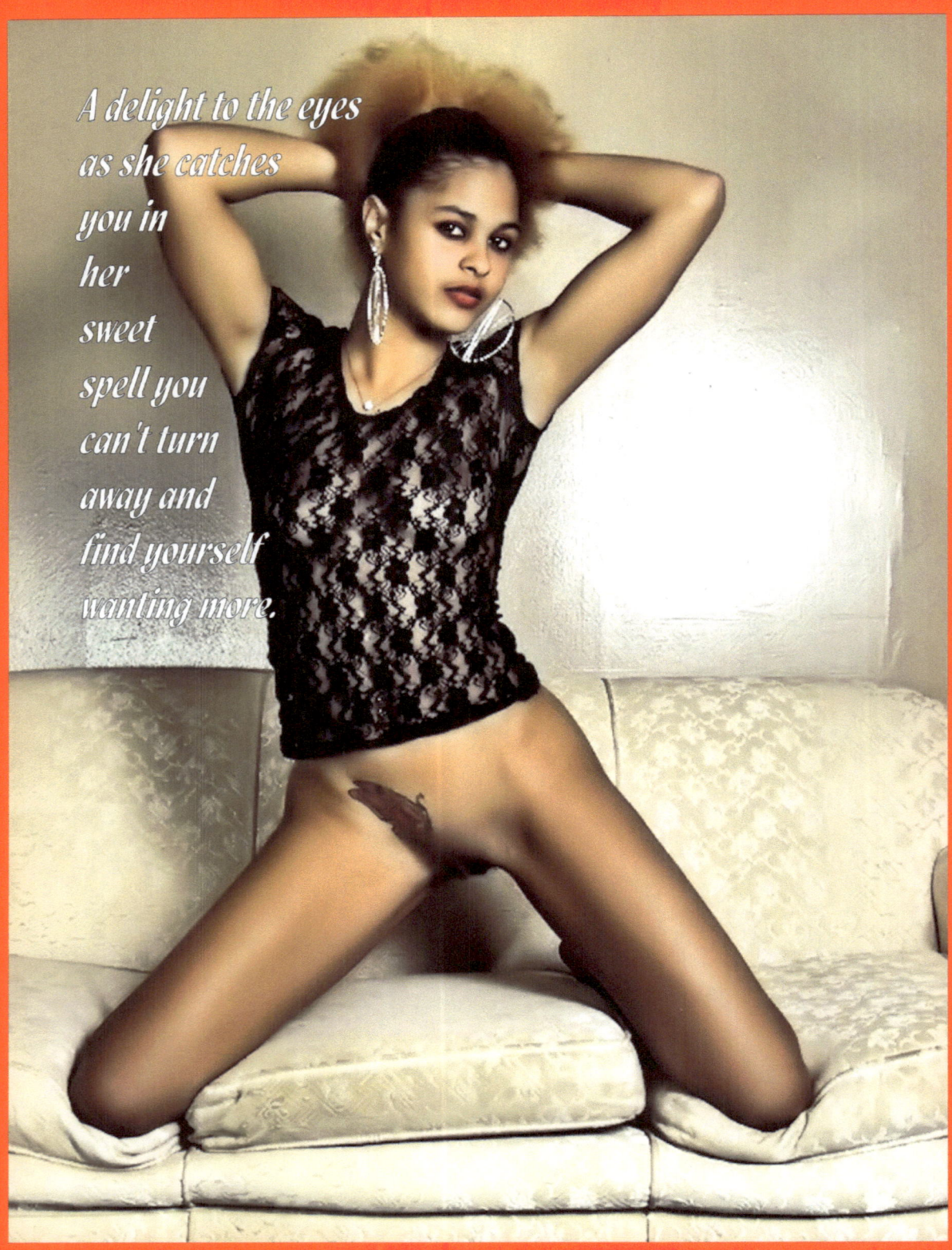

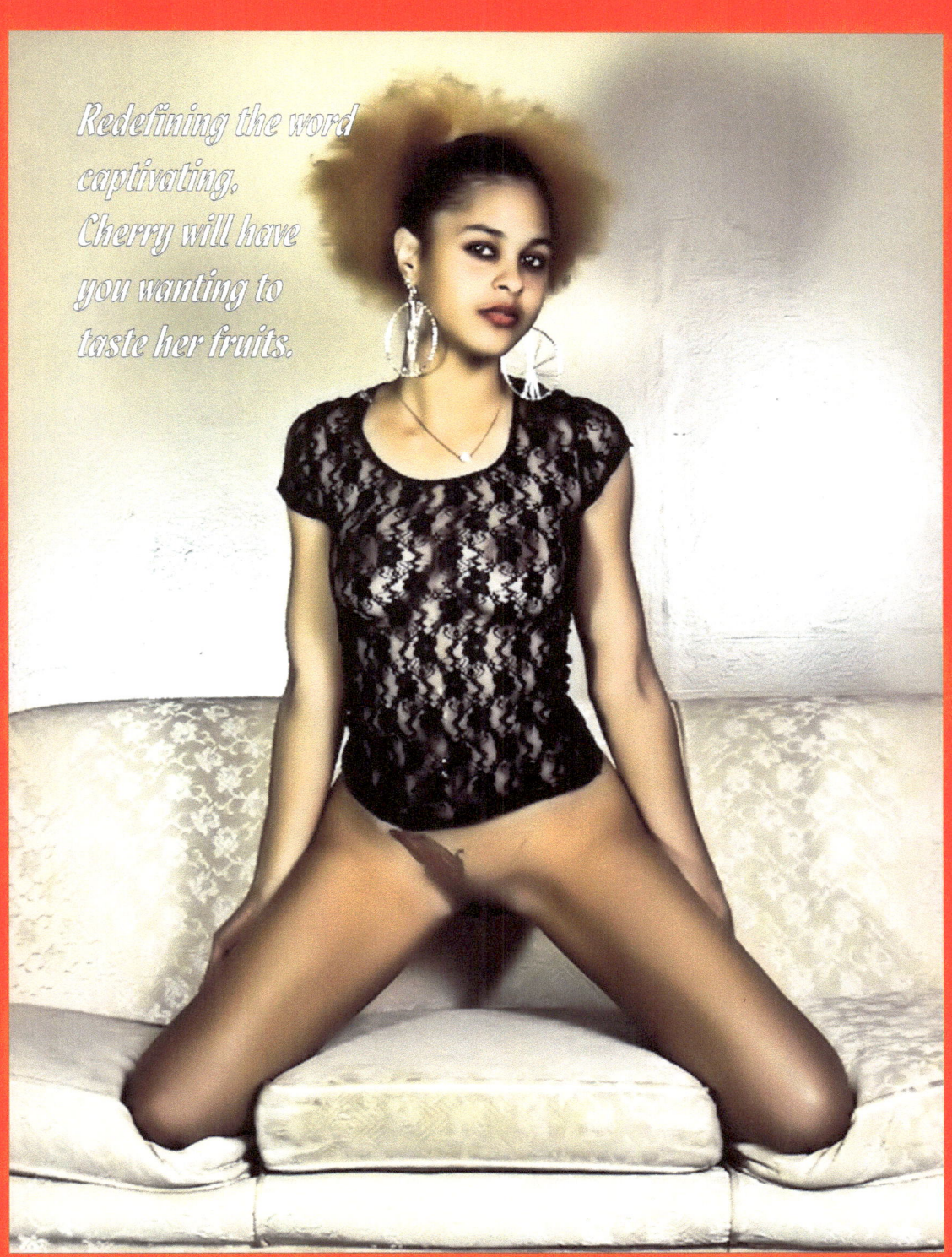

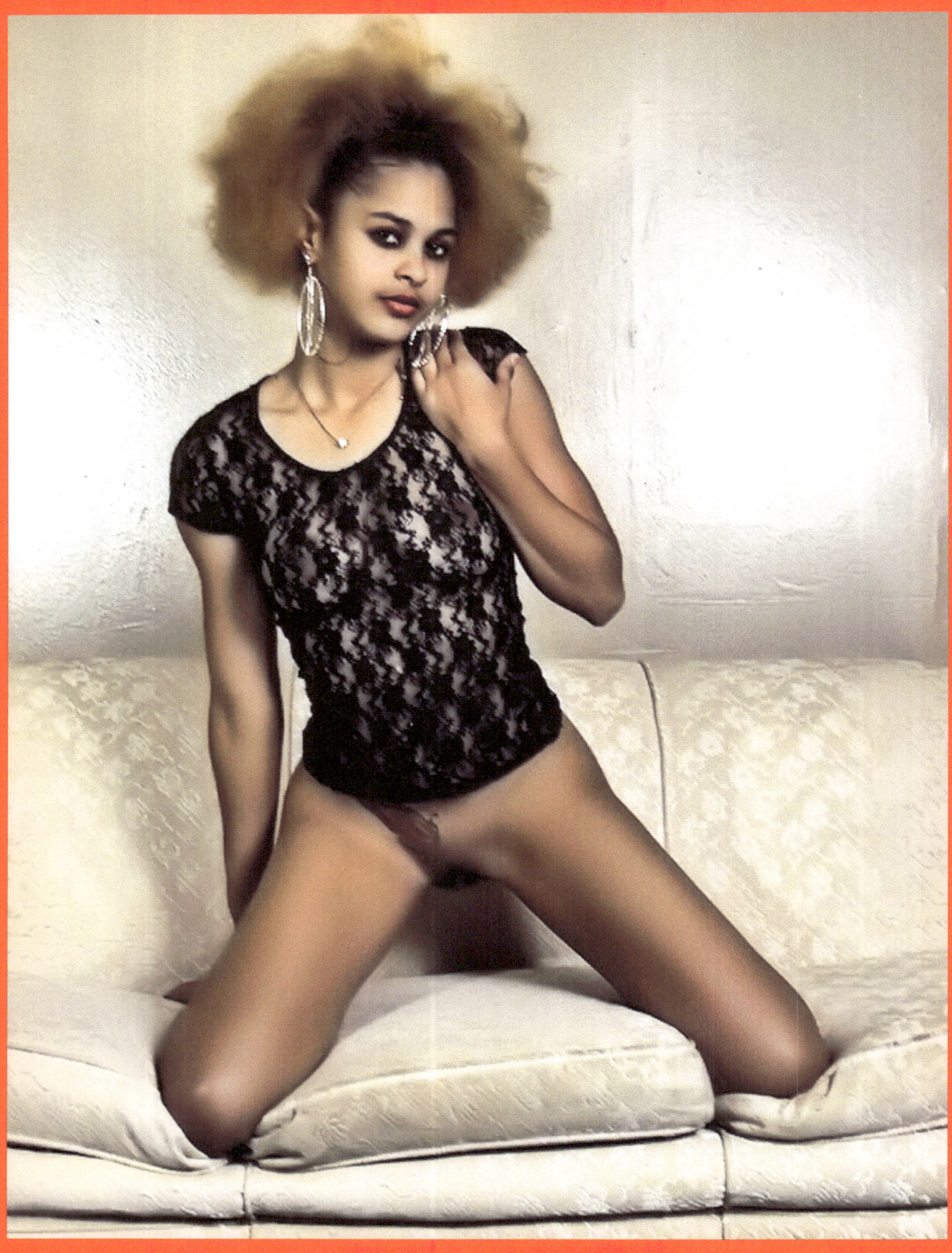

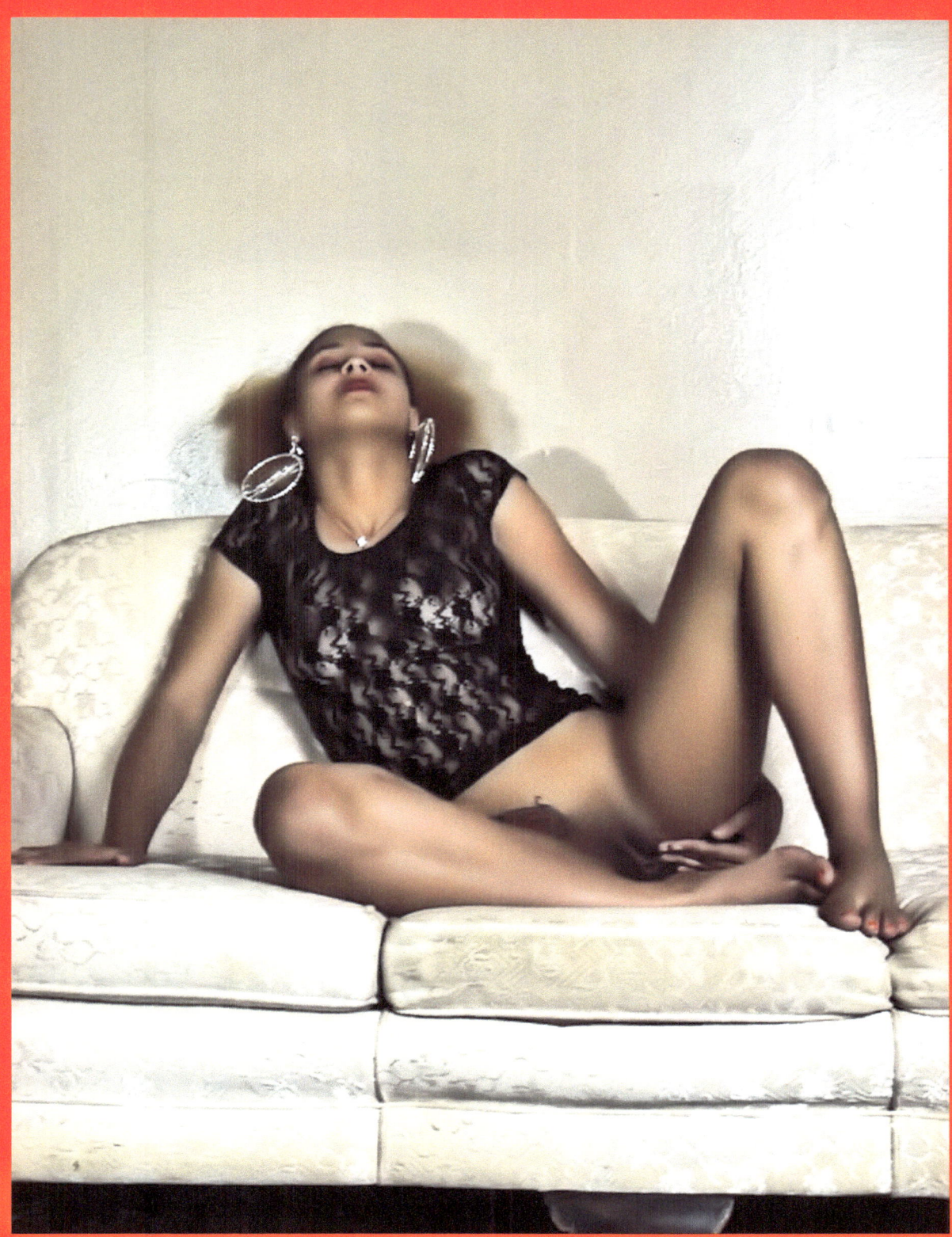

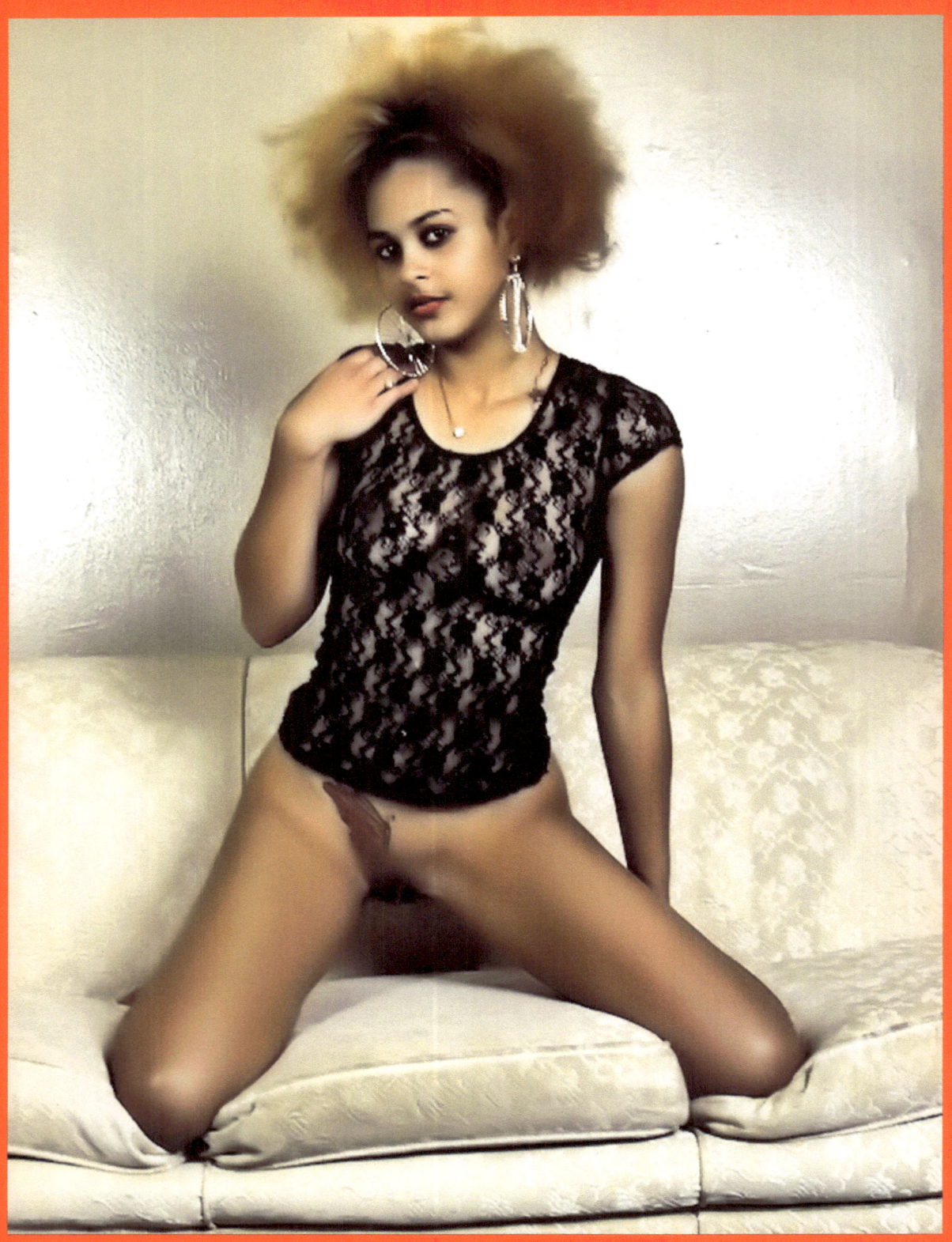

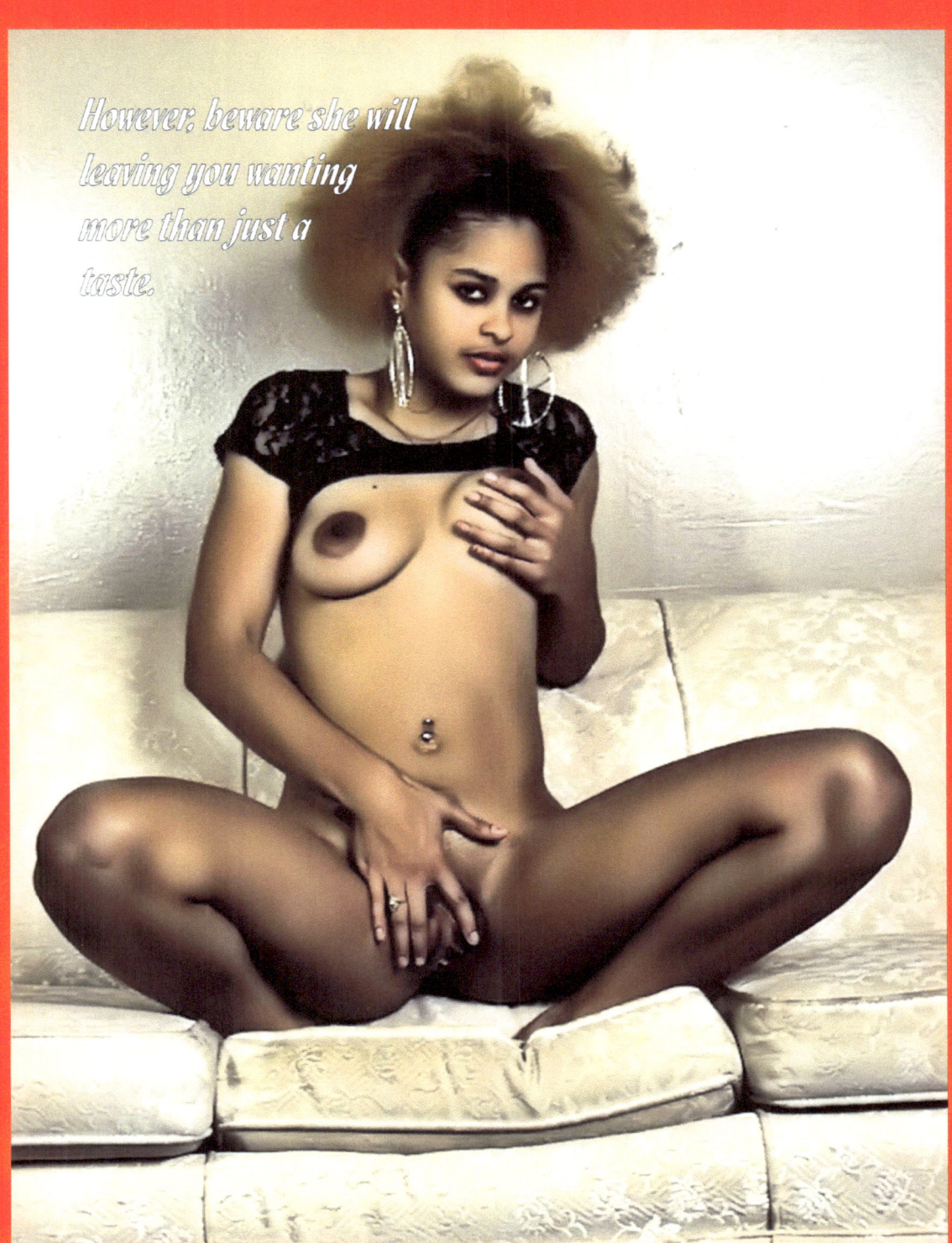

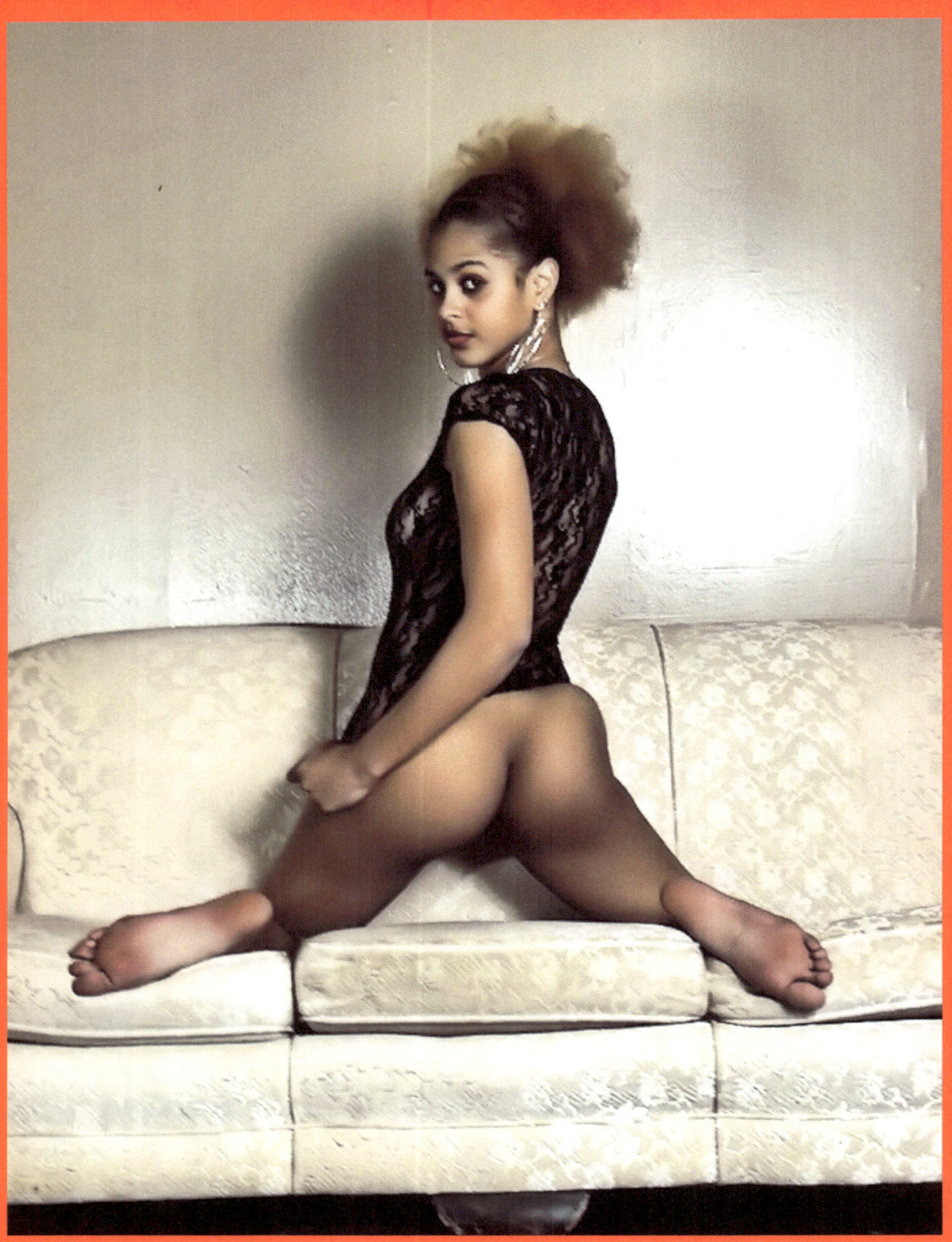

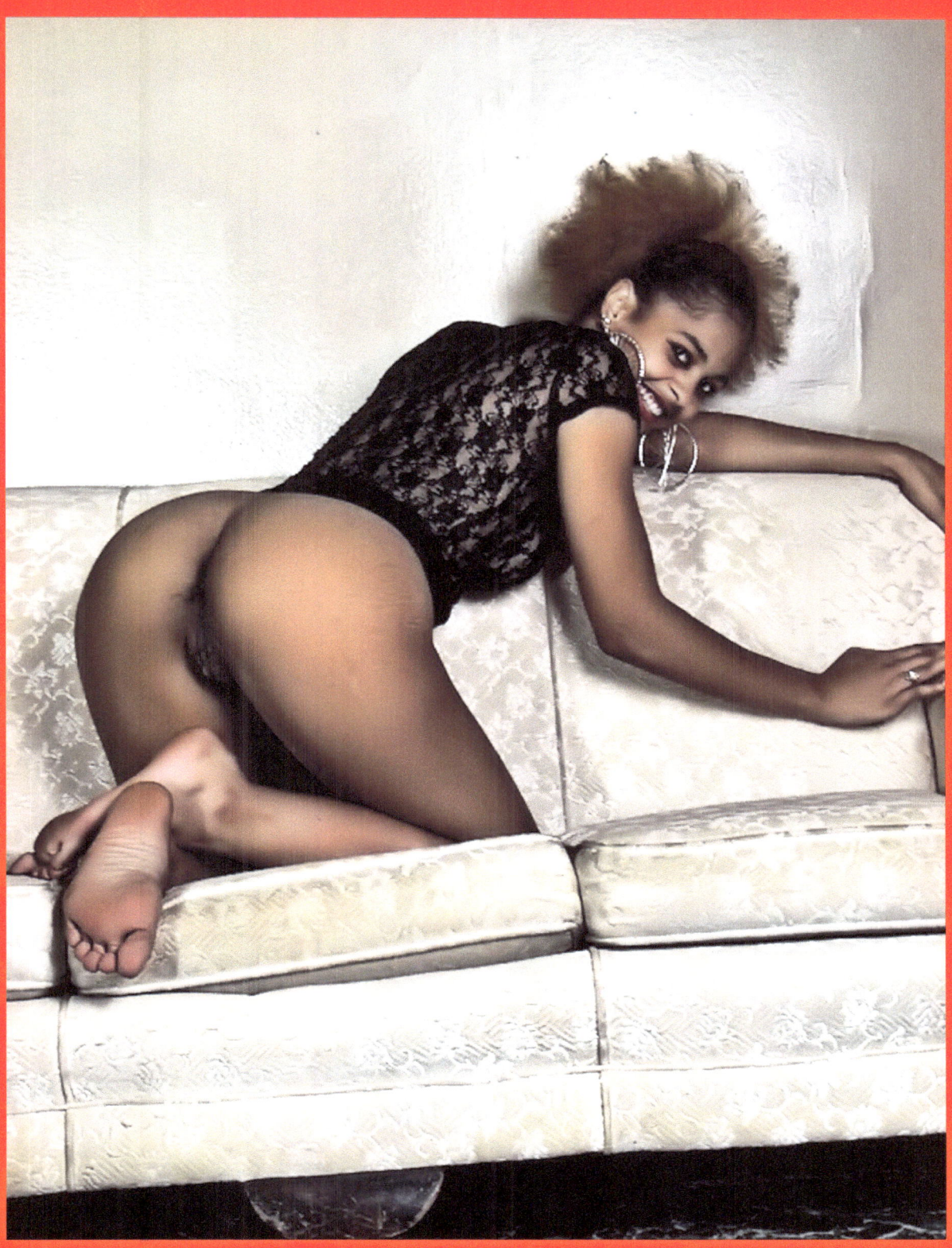

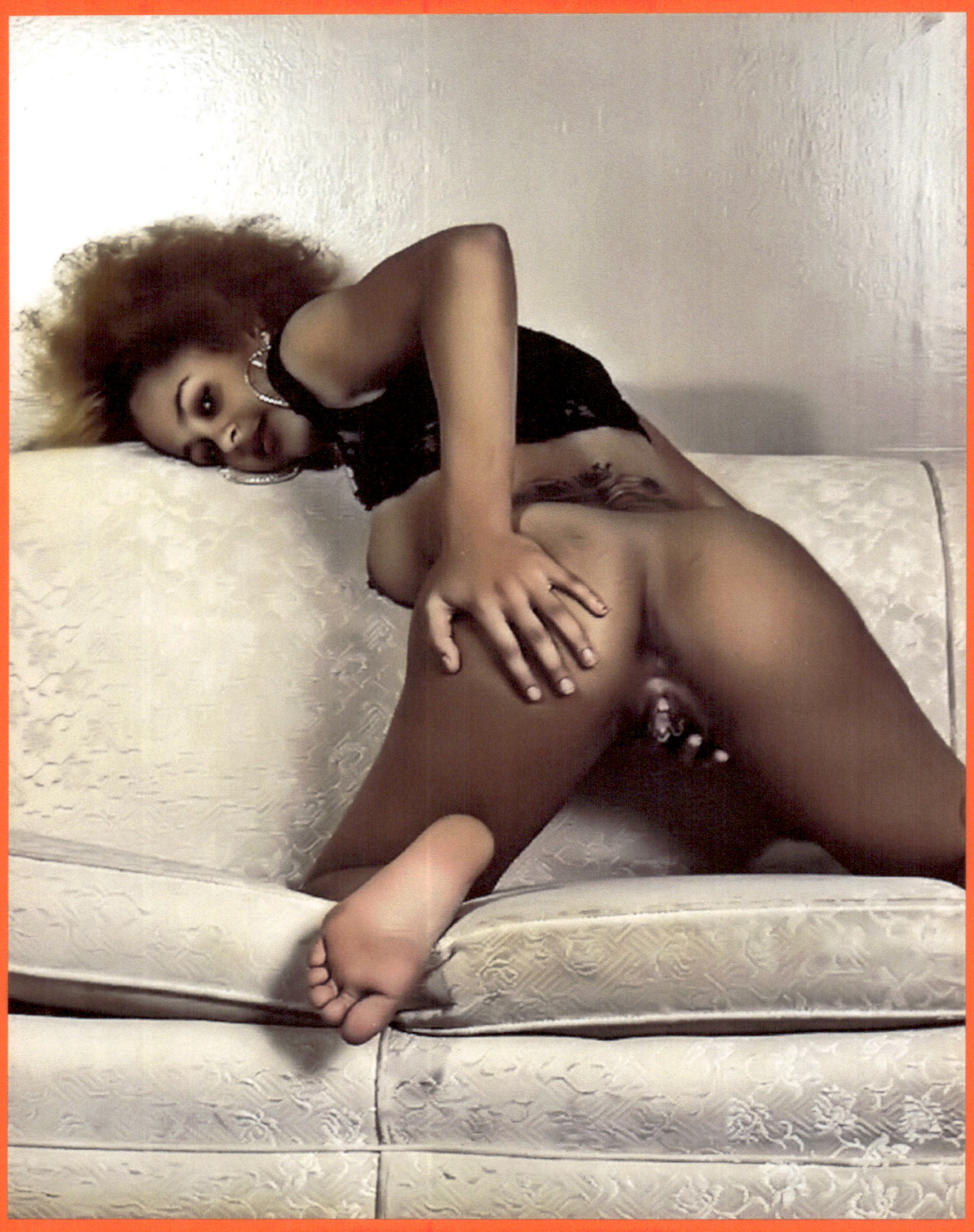

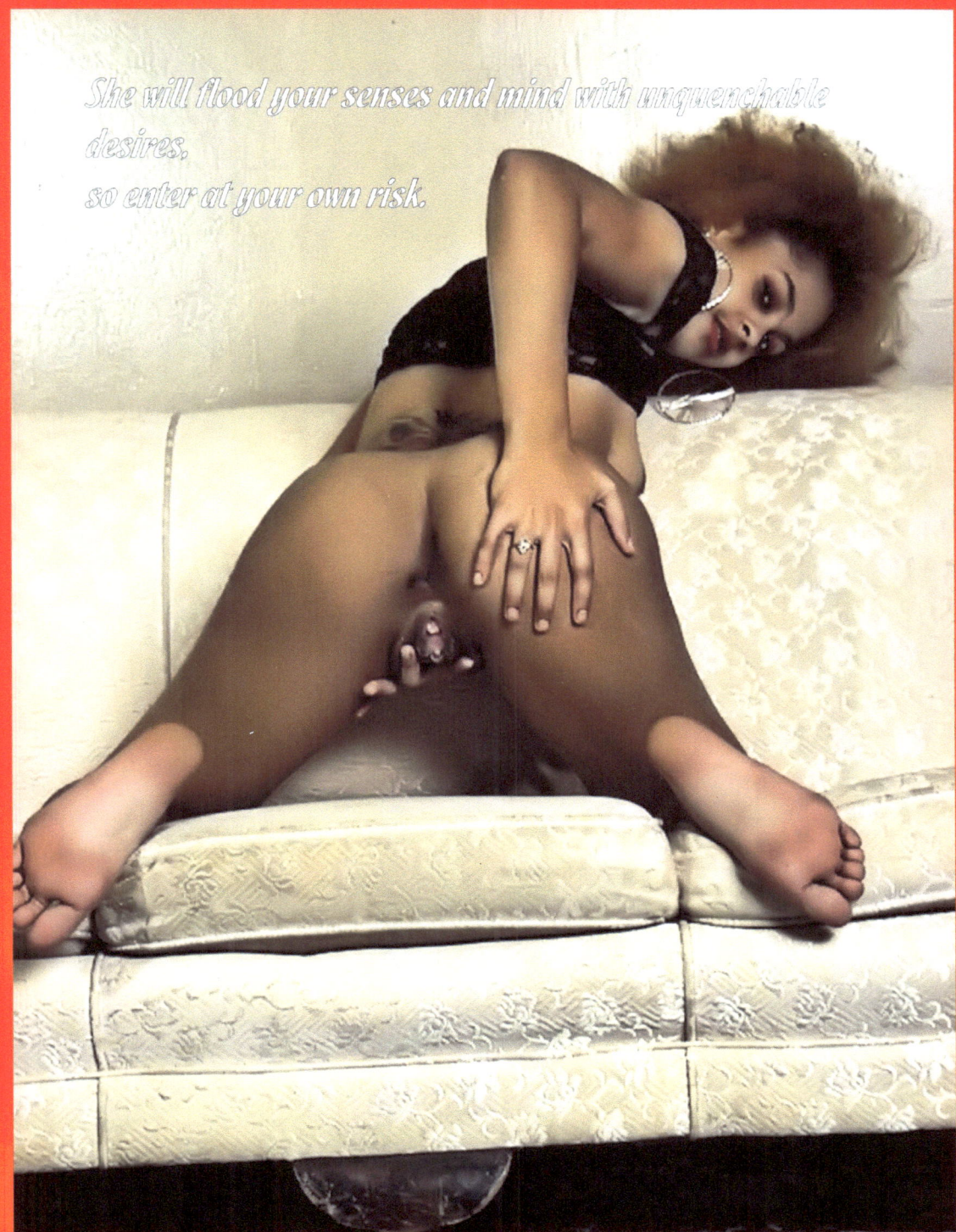

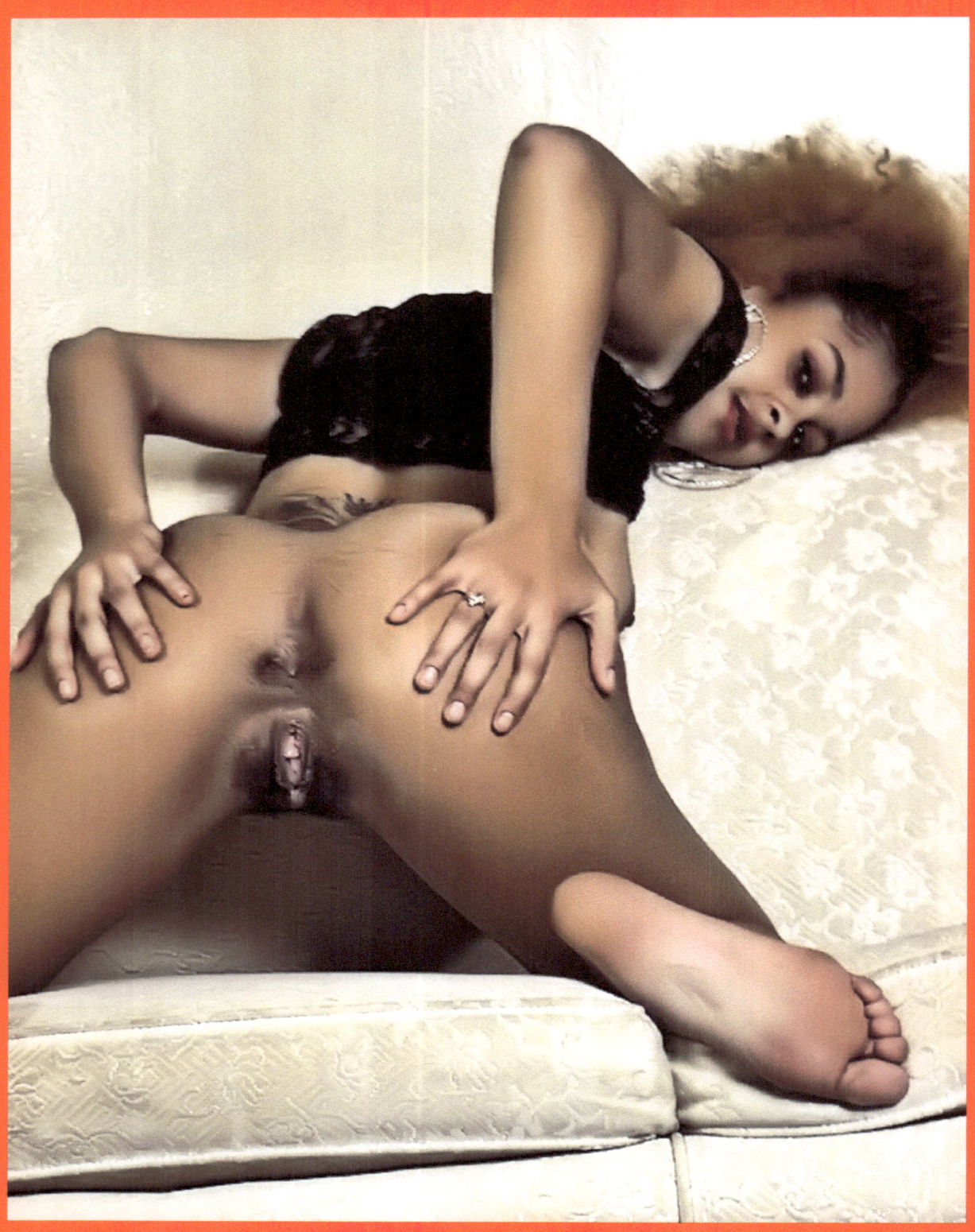

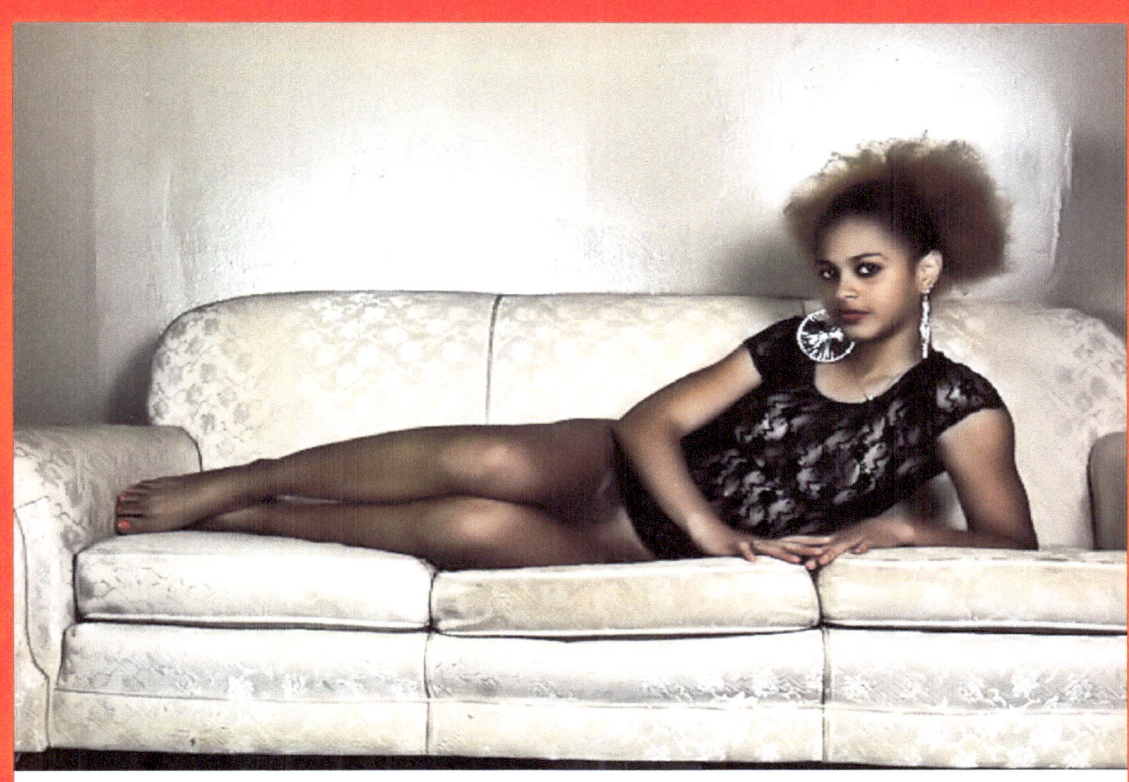
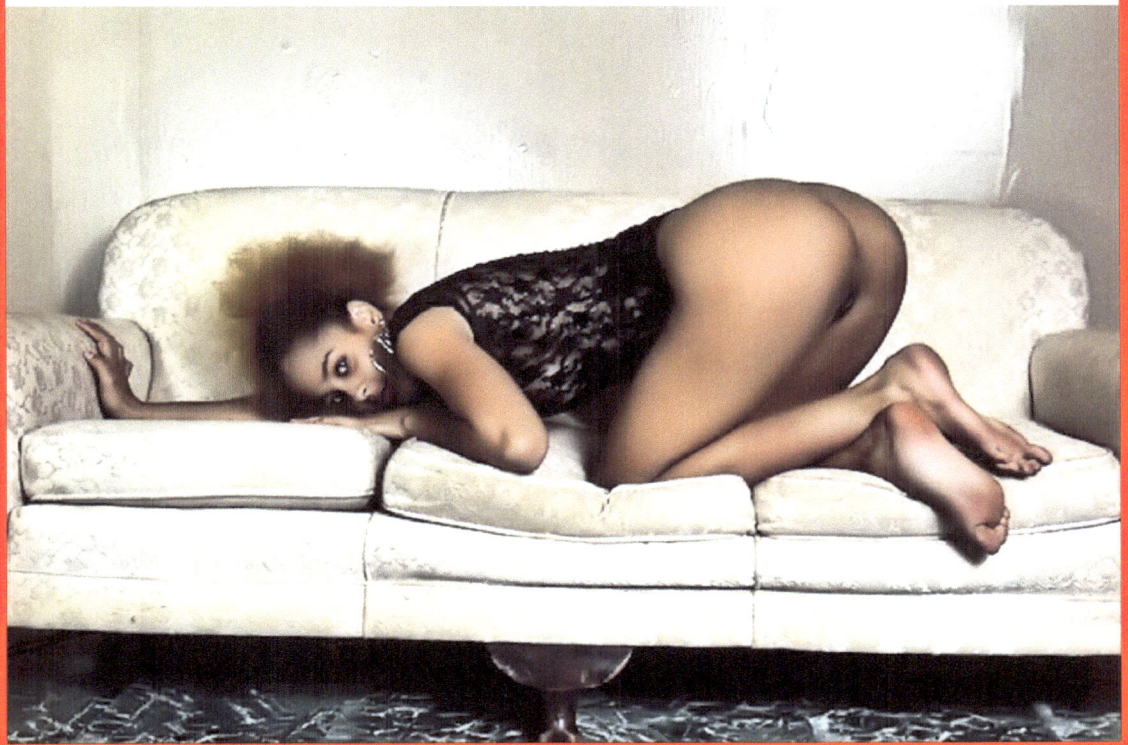

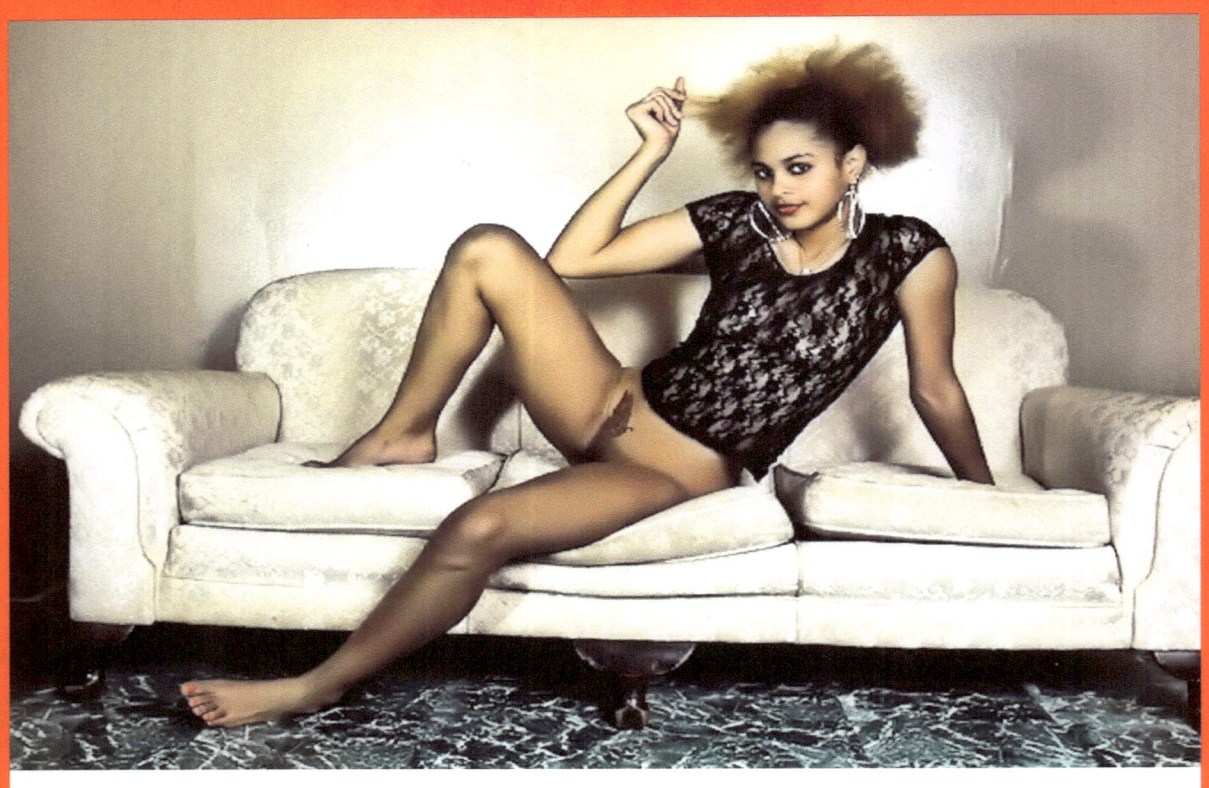
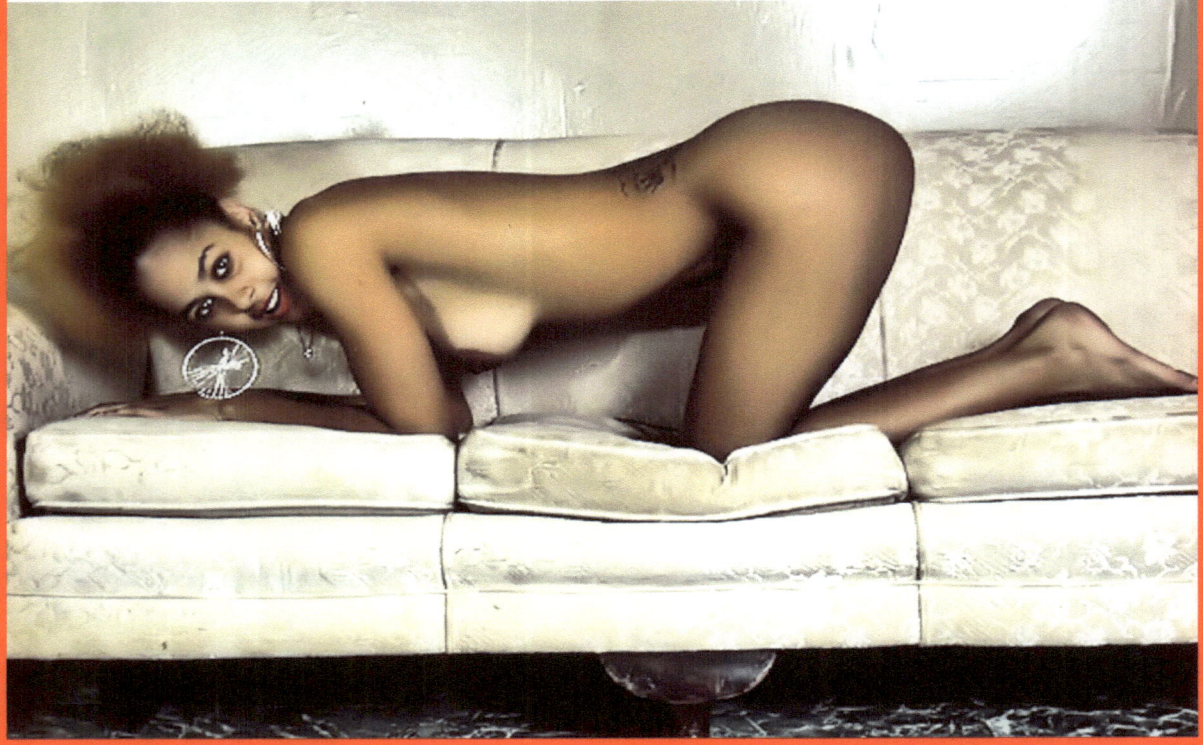

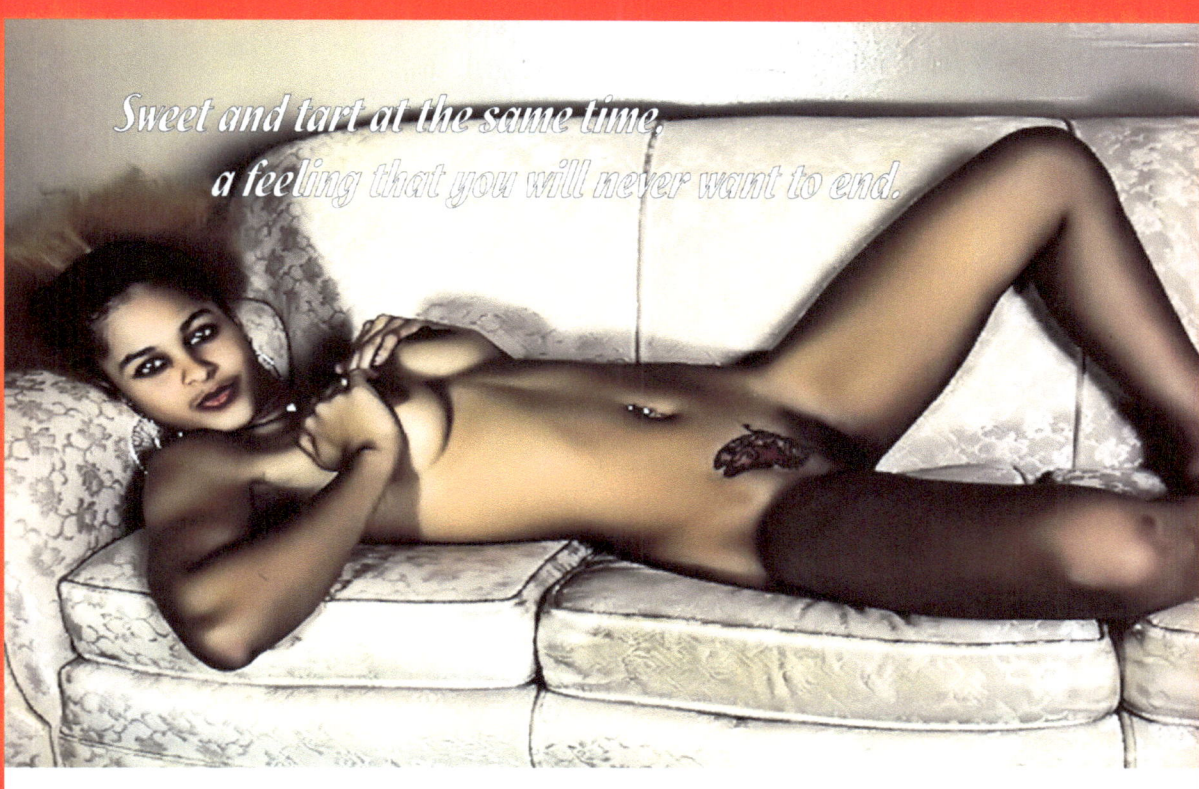

Sweet and tart at the same time, a feeling that you will never want to end.

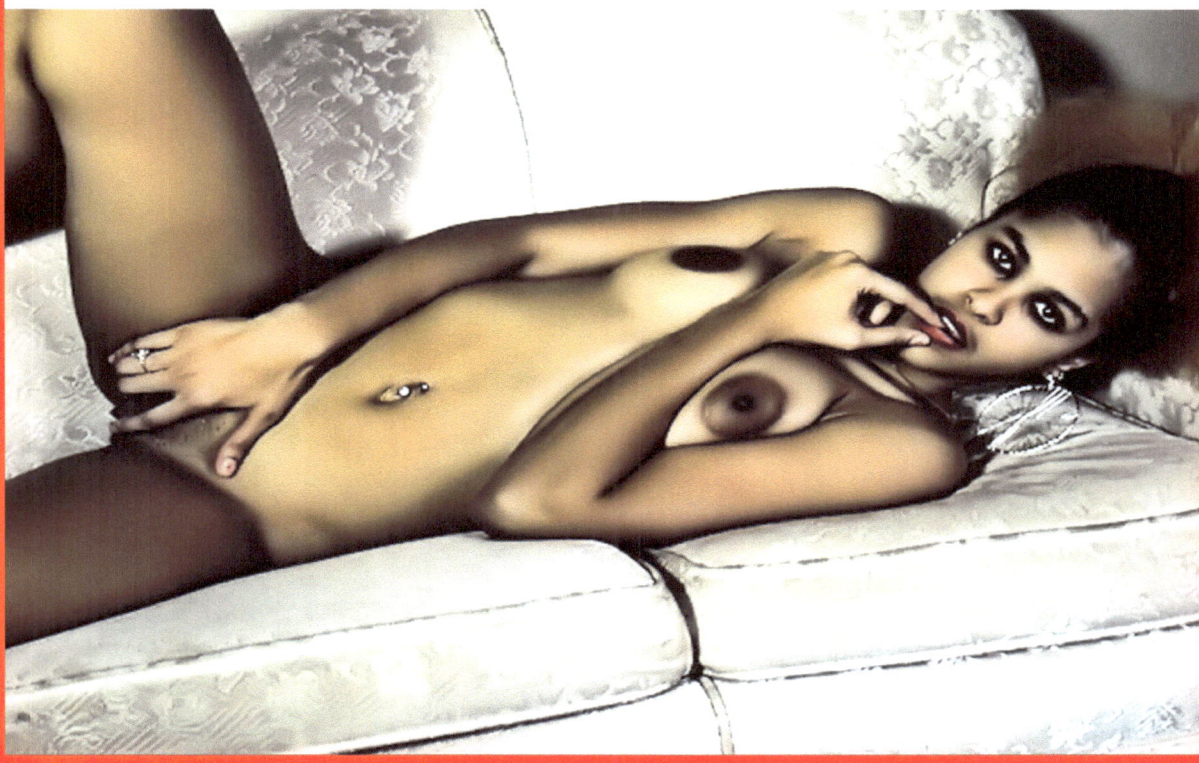

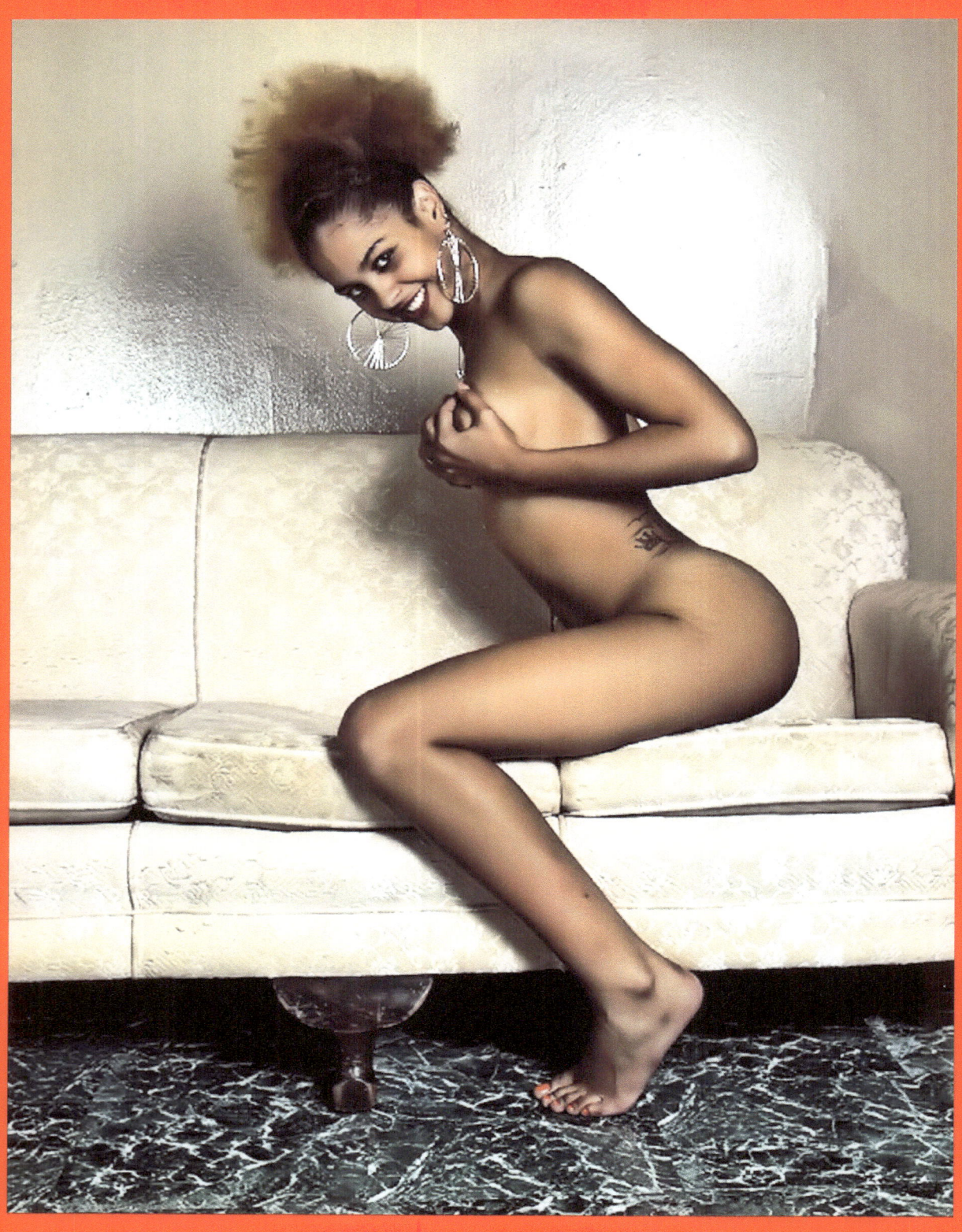

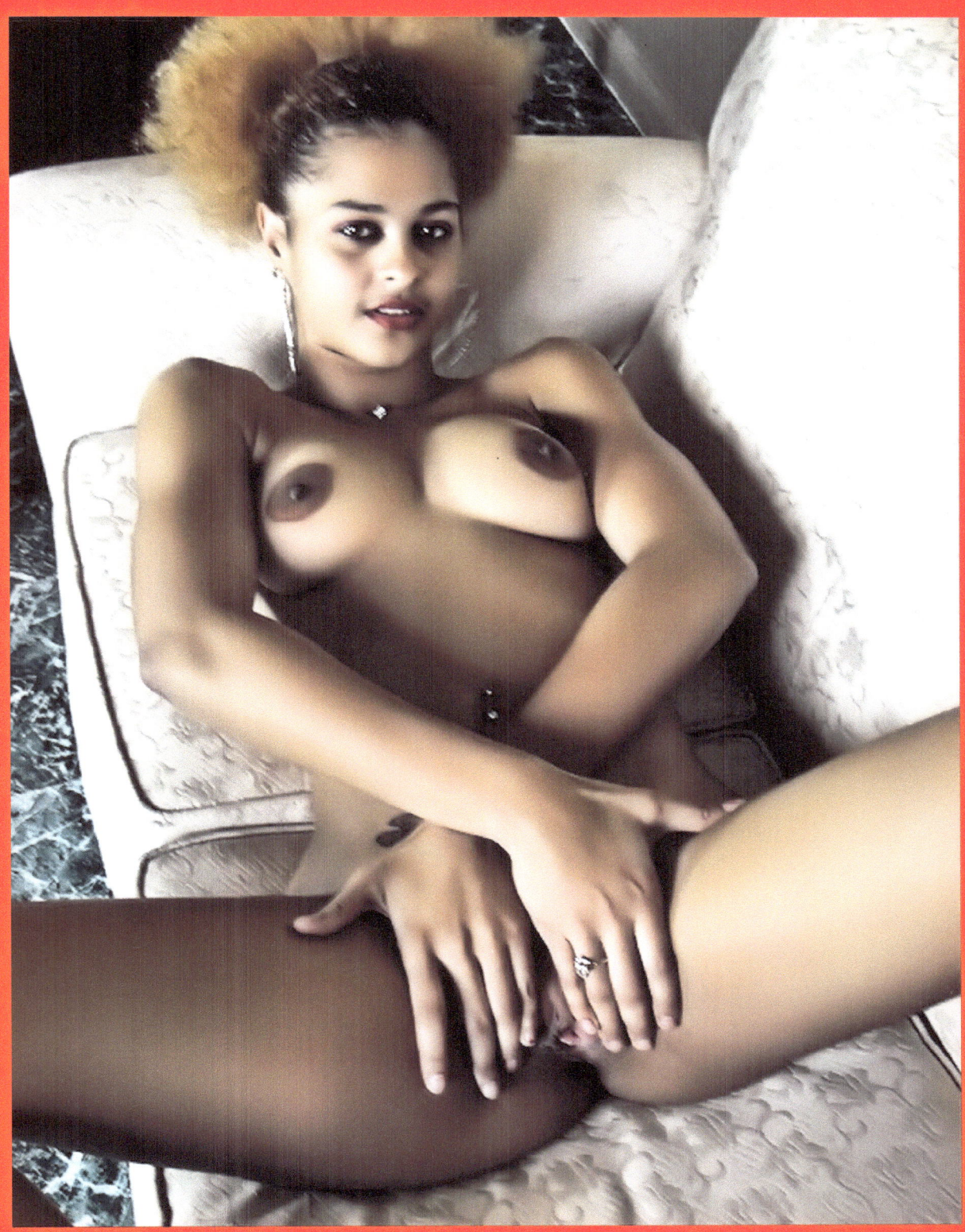

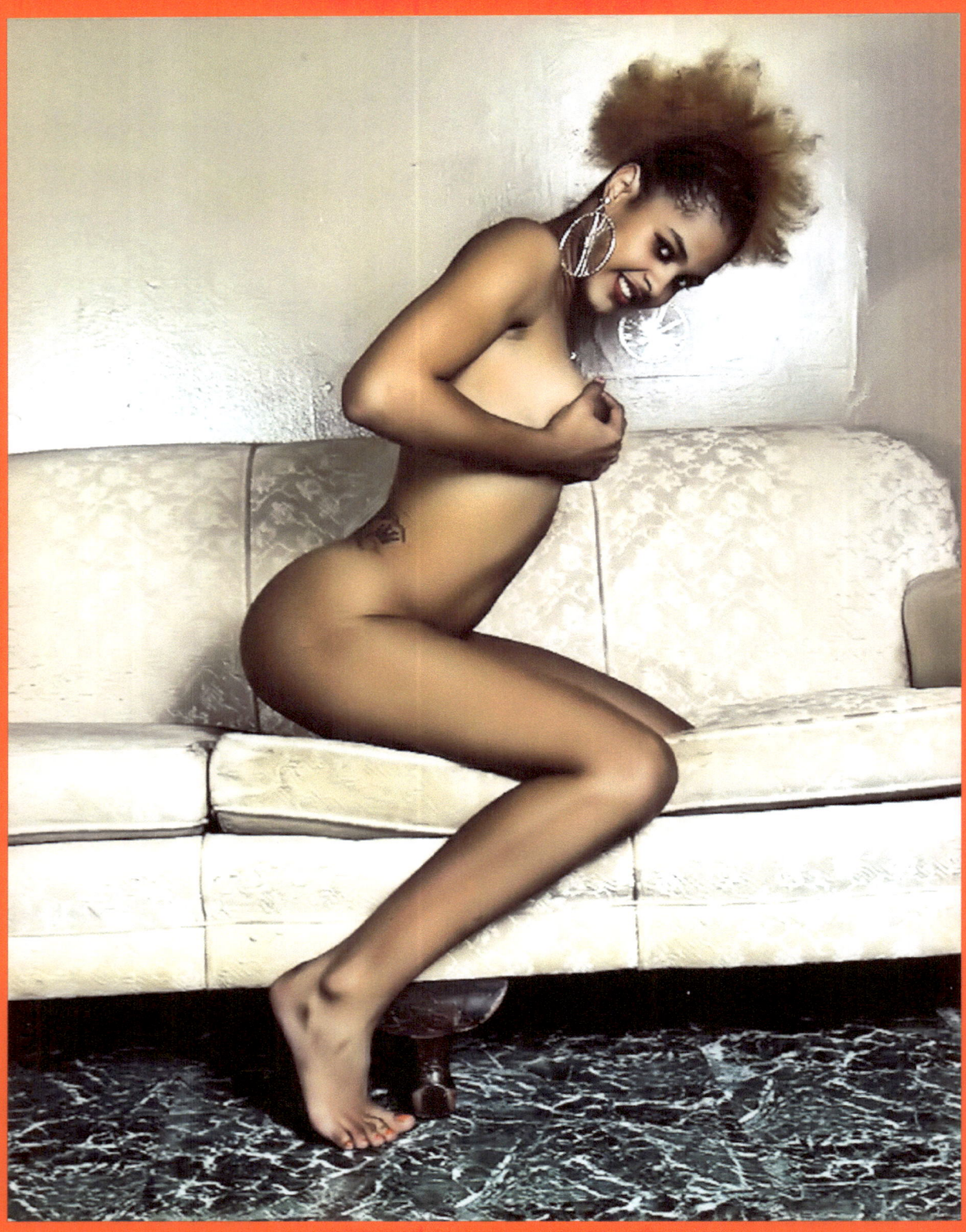

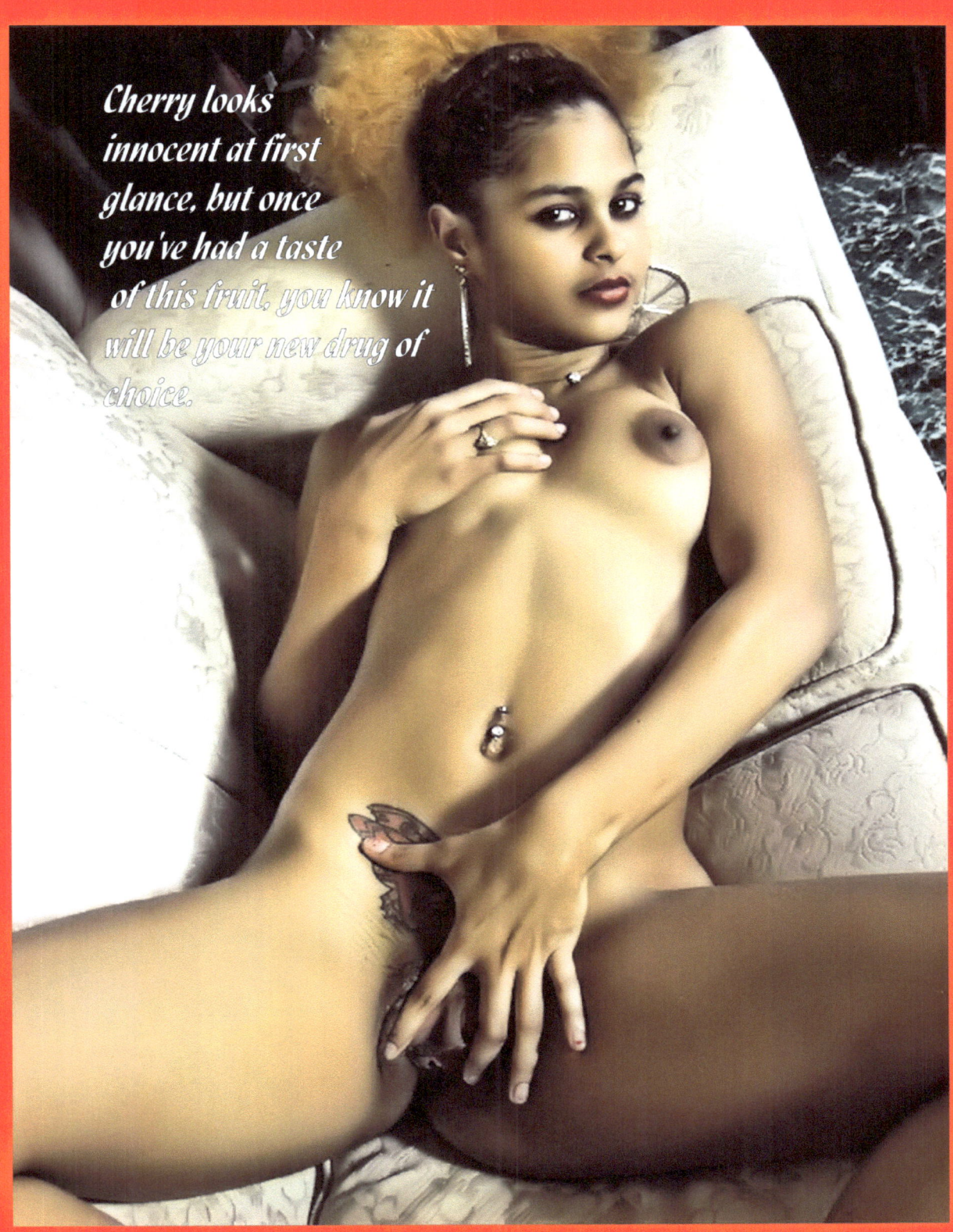

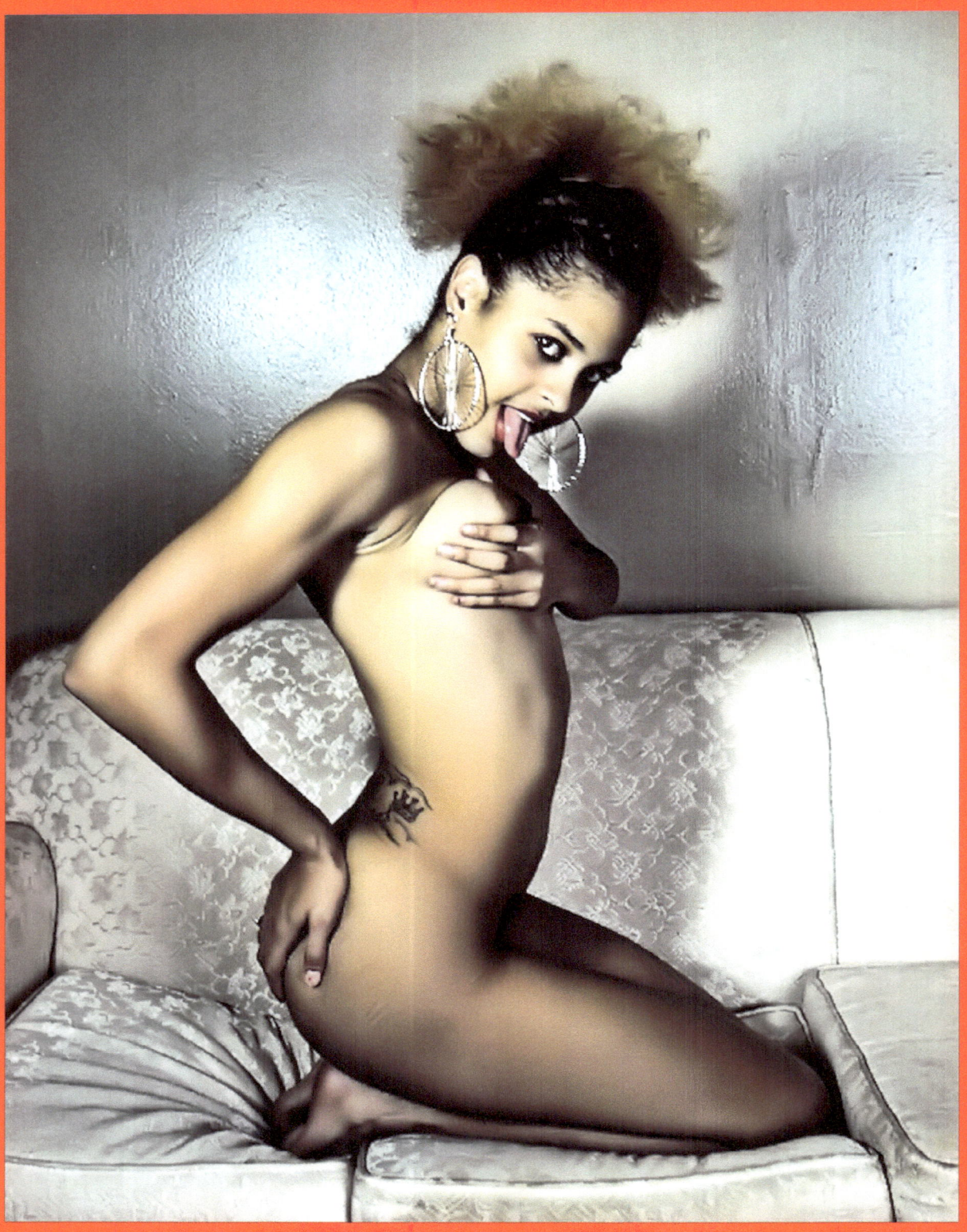

http://www.modelturf.com/chocolatebottoms

MODEL TURF

Logout

- Main
- Status Updates
- Search
- My Turf
- My Turf
- Account Info
- My Mail
- My Shouts
- Share your Portfolio
- Update Wall
- Manage Photos
- Manage Videos
- Manage Music
- Edit Bio
- My Details
- Blocked
- Settings
- Casting
- Post Casting
- Photo Battle
- Best Photos
- Add Photo
- Start New Match
- Blogs
- My Blogs
- Post A Blog
- Support
- Contact Us

MT#

Chocolatebottoms.com Ent

Male
41 years old
Mableton Georgia, United States
www.chocolatebottoms.com

Now Playing: can i hit them skinz

00:24 03:58

About me

I want to make every model life complete. I am looking to photograph every model that is rare, fine, and curvy. Because none of the models are the same. I would like to work with models that are diverse in many ways from their hobbies, professions, figures, and aspirations in this world of ours.

Chocolatebottoms.com Ent has 294 Friends

(18) (5)

Info

Profession: Photographer #140
Joined: 2009-12-21

Recent Visitors

JGT Photography Of CT / Photographer
REDD DIAMOND / Model
Aundrea Taylor / Photographer
Lovjonz / Model
RobertBrownModels / Casting Agent

Administrator	Not specified	Website Owner	Model
MT Admin			
Admin	Reggie	IReviewHipHop Magazine	Andrea C.
Model	Model	Model	Model
Kandi	Treasury	Christian Hoke	Big Phil
Model	Model	Photographer	Photographer

www.modelturf.com/chocolatebottoms

www.ingramcontent.com/pod-product-compliance
Lightning Source LLC
Chambersburg PA
CBHW050434180526
45159CB00006B/2531